This is Pollock

Published in 2014 by
Laurence King Publishing Ltd
361–373 City Road
London EC1V 1LR
Tel: +44 20 7841 6900
Fax: +44 20 7841 6910
email: enquiries@laurenceking.com
www.laurenceking.com

A catalogue record for this book is available from
the British Library.

ISBN 13 : 978 1 78067 346 2

Book design: The Urban Ant

Series editor: Catherine Ingram

Printed in China

This is
Pollock

CATHERINE INGRAM
Illustrations by PETER ARKLE

LAURENCE KING PUBLISHING

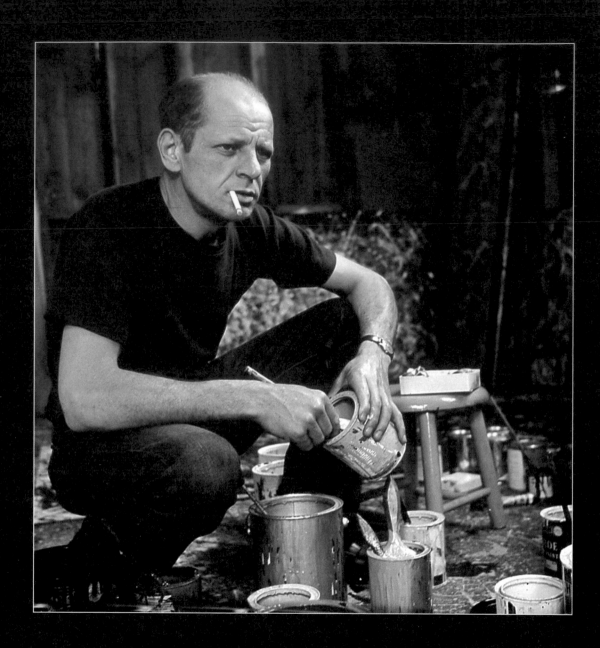

Jackson Pollock in his studio, 1950.
Photo by Rudy Burkhardt.

Jackson Pollock looks like, as his friend Willem de Kooning put it: 'some guy who works at the service station pumping gas'. He stares blankly without making eye contact. An intense character, he was uncomfortable in his skin, and found talking almost painful. People were wary of him. It didn't help that he was often drunk.

Pollock's drunken antics have fuelled a powerful mythology. The artist has been projected as a reckless cowboy figure – a prototype for the Beat generation. In his lifetime disgruntled photos of him were plastered across the American glossies. Pollock resented his public image, and yet he kept satisfying the mythmakers with more displays of bad behaviour.

Pollock's career needs to be untangled from the bad boy storyline. His iconic drip paintings were painted when he was dry and living a very normal life with his wife on a farm in rural Long Island. This photo captures Pollock in his studio. Crouched on the floor, he slowly mixes the paint in the pot, ready to begin work. Pollock became focused when he painted. The wooden, awkward man would move with grace, creating delicate, fluid works of art.

In 1871 the poet Walt Whitman had declared, 'America demands a poetry that is bold, modern and all-surrounding and kosmical, as she is herself.' Pollock's monumental drip paintings reflect a uniquely American vision. Sixty years on, they still look bold and modern.

An Uncertain Power: Post-War America

By the end of World War II, America's morale was in tatters – a response that social theorist Dwight Macdonald attributed to the 'fraudulent character' of the war. American soldiers had walked into Nazi concentration camps and witnessed their full horror, while the Allies' victory had come to seem empty, overshadowed by the bombing of Hiroshima and Nagasaki. American airmen had dropped Little Boy and Fat Man on these towns, unleashing devastating radiation that obliterated the cities, and killed over 200,000 civilians. Flying home after the bombing of Hiroshima, co-pilot Robert Lewis asked, 'What have we done?'

In the midst of such uncertain times America experienced sudden economic growth. Historian Harold Vatter describes the boom in the domestic and international markets:

> Cars, television sets, and household appliances
> poured off assembly lines as America continued
> to develop as a consumer society... [as] American
> multinationals, in particular, greatly increased their
> involvement in the global economy...

This rapid emergence as a new superpower meant everything else had to play catch-up; the Brave New World needed a cohesive national identity. Dismayed by the political situation, people looked to visionary individuals. Macdonald himself vested hope in the ability of the artist and intellectual to rekindle faith in humankind.

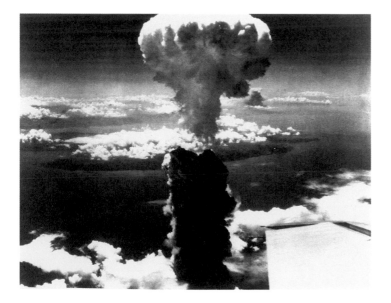

Atomic bomb over Nagasaki,
9 August 1945.
US Air Force archive.

American Art

America's art scene lacked confidence; for a long time it had been a chameleon, absorbing outside influences. During the Depression of the 1930s, many artists looked to Soviet Communism, and developed Social Realist art that espoused Communist ideals. However, as the decade wore on, sympathizers were disillusioned by Joseph Stalin's punitive policies, and his decision to sign a pact with Fascist Germany.

Artists were also becoming increasingly frustrated by US president Franklin D. Roosevelt's New Deal, which had been intended to bring the country out of economic depression, but had instead turned into a bureaucratic farce. After the Works Progress Administration (WPA) was established in 1935, artists could sign up and be paid a salary ranging from $15 to $90 a month. The purpose was to create public art; however, the paintings were usually piled into storerooms and then later dumped. In one clearout in 1941, 650 WPA watercolours were incinerated, among them 12 works by Jackson Pollock.

Yet there was also a buzz in the New York art scene at this time; artist Barnett Newman described 1940 as a 'naked revolutionary moment'. In the next few years a new art would emerge, which would come to be known as Abstract Expressionism, and the press would pick out Jackson Pollock as the leader and 'enfant terrible' of the group.

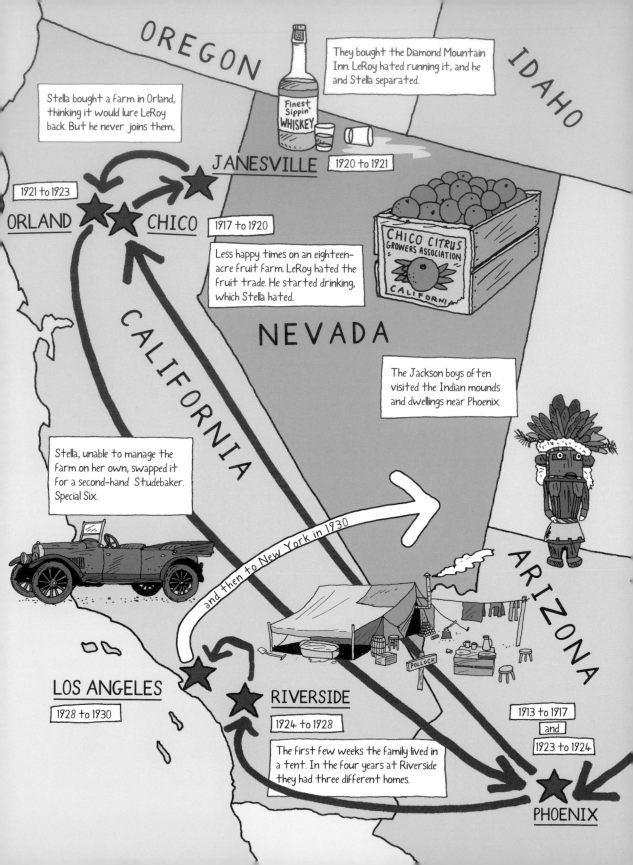

OREGON

IDAHO

Stella bought a farm in Orland, thinking it would lure LeRoy back. But he never joins them.

They bought the Diamond Mountain Inn. LeRoy hated running it, and he and Stella separated.

Finest Sippin' WHISKEY

JANESVILLE

1920 to 1921

1921 to 1923

ORLAND

CHICO

1917 to 1920

CHICO CITRUS GROWERS ASSOCIATION

CALIFORNIA

Less happy times on an eighteen-acre fruit farm. LeRoy hated the fruit trade. He started drinking, which Stella hated.

NEVADA

CALIFORNIA

The Jackson boys often visited the Indian mounds and dwellings near Phoenix.

Stella, unable to manage the farm on her own, swapped it for a second-hand Studebaker. Special Six.

and then to New York in 1930

ARIZONA

POLLOCK

LOS ANGELES

1928 to 1930

RIVERSIDE

1924 to 1928

1913 to 1917
and
1923 to 1924

The first few weeks the family lived in a tent. In the four years at Riverside they had three different homes.

PHOENIX

CODY ★

Born 28 January 1912

WYOMING

UTAH

COLORADO

NEW MEXICO

KANSAS

THE TRAVELLING FAMILY

Jackson was born in Cody, Wyoming to Stella and LeRoy Pollock. When he was just ten months old, the family left. Driven by Stella's aspirations for a better life, the Pollocks were constantly on the move, but their journey around the West became a desperate downward spiral. With every move their landholdings diminished, and the moves became more and more frequent. After LeRoy left them in Janesville, the journey turned into a chase as Stella pursued her husband. In Orland she swapped their last farm for a second-hand car, and carried on to Los Angeles with her quest.

In later years Pollock behaved like a cowboy, wearing pointed cowboy boots, sitting wide-legged and busting up bars. Yet his identification with the West was abstract: he didn't visit the area much. Undoubtedly, his perception of the place was tied up with his unstable family life.

They were happiest on their farm in Phoenix, Arizona. Years later, LeRoy admitted to one of his sons, 'I wish we were all back in the country on a big ranch with pigs, cows, horses, chickens… We did lots of hard work, but we were healthy and happy.'

All mothers are giants
– Jackson Pollock

In the archives of the Smithsonian Institution there are some
snapshots from Pollock's childhood. In one photo a robust-looking
Stella, with child on hip, strides past some farm machinery
and chickens; it was Stella's job to slaughter the chickens. Her
capabilities made her a formidable force in the family. Pollock's
future wife Lee Krasner describes her first meeting with 'Mother':

> I was overpowered with her cooking, I had never
> seen such a spread as she put on. She had cooked
> all the dinner, baked the bread, the abundance of it
> was fabulous. I thought Mama was terrific... It took a
> long time for me to realize why there was a problem
> between Jackson and his mother. You see, at that time
> I never connected the episode of Jackson's drinking
> with his mother's arrival.

Stella grew up when America's great railroads were being laid.
According to social theorist Marshall McLuhan, 'The railway
radically altered the personal outlooks and patterns of social
interdependence. It bred and nurtured the American dream.'
Stella's trip around the West was driven by the notion that a
better life existed beyond the next frontier. She moved her
family to Chico after reading an article in a glossy magazine that
described a smart town with 'tree-lined avenues'. Appearances
mattered. A dressmaker, she transformed her farm boys into fine
young men. For Pollock, who often faced the trauma of being the
new kid, it just meant that he stuck out more.

The Absent Father, LeRoy

LeRoy was an escapist who loved a drink. His sons thought of him as a sensitive man, and in their letters they wrote to him about culture and politics. When Jackson was 15 years old, LeRoy took him and his brother Sanford ('Sande') on a road trip through the Grand Canyon. This photo shows a rare moment with his dad, who was mostly absent from their lives. Looking out at the Rocky Mountains, Jackson sits behind his father, who dangles his legs precariously over the edge. Historians have argued that Pollock's monumental canvases reflect the scale and openness of the Western landscape.

During their trip, LeRoy and the boys worked for a while, surveying new road on the northern stretch of the canyon. According to Sande, Jackson enjoyed the labour. Described as being 'born with too big an engine', work was a release for Pollock, who as an adult admitted, 'Painting is no problem; the problem is what to do when you're not painting.' Pollock was happiest when the engine was firing full blast: in the first few years of living in Long Island in the 1940s, he produced painting after painting, while he also renovated the house, moved his studio and improved the land.

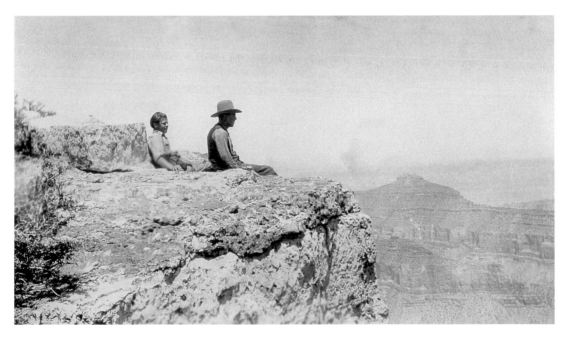

Jackson and LeRoy Pollock,
Grand Canyon, 1927.

Manual Arts High School 1928–30

In Los Angeles Jackson attended the Manual Arts High School for a couple of years before he was expelled for ridiculing the gym teacher. On the whole, though, it was a positive experience. Pollock liked the art teacher, Frederick Schwankovsky, who became a role model for him. He grew his hair long like his teacher, and absorbed his Communist ideals. Serious about his subject, Schwankovsky insisted that his students learnt to draw well and, somewhat controversially, he hired live models.

Refreshingly, Pollock wasn't an obvious artistic prodigy. He struggled with the work, and was very aware of his own failings: 'my drawing i will tell you frankly is rotten it seems to lack freedom and rythem it is cold and lifeless [sic].' His brother Sande put it plainly: 'If you had seen his early work you'd have said he should go into tennis, or plumbing.'

Krishnamurti

In 1928 Schwankovsky invited the international spiritual leader Jiddu Krishnamurti to come and talk to his students. Afterwards, Pollock started attending meetings at Krishnamurti's Pepper Tree Retreat in the Ojai Valley. As biographer Deborah Solomon explains, 'It is not difficult to understand Pollock's identification with Krishnamurti, a gentle, sensitive heretic who, according to his writings, had been unhappy in his youth and determined to find a goal, any goal, to which he could devote himself completely.'

Krishnamurti spoke to the disenchanted. Distilling the tenets of Eastern thought for a Western audience, he advocated solitude for everyone. For Krishnamurti, only by being alone could one find clarity, be self-aware and experience the full splendour of the natural world: 'the plants, the animals, the trees, the skies, the waters of the river, the bird on the wing'. Although Pollock would soon inform his brothers, 'I have dropped religion for the present', years later he was still talking about Krishnamurti. Pollock's decision to leave bustling New York for a farm in the marshland of Long Island might have been guided by Krishnamurti's philosophy. His signature period of painting (developed in the quiet of Long Island) is also premised on a sensitivity to nature.

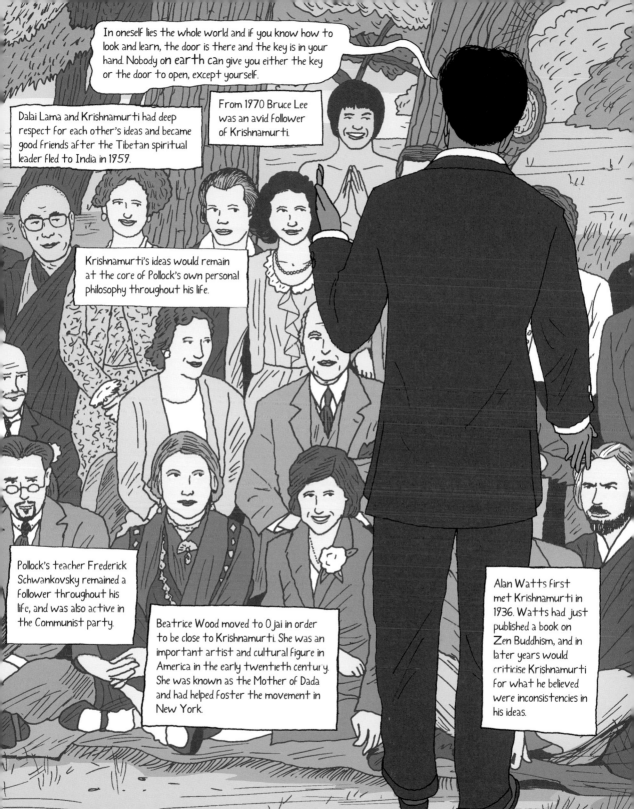

The American Man Hut

Solitude is an age-old quest, but for America – the New World – it had a political significance: it was about national confidence. It also came to be strongly associated with the transcendentalists, who believed that self-reliance amidst nature enabled man to achieve true spiritual insight. In an 1837 speech entitled 'The American Scholar', the leader of this movement, Ralph Waldo Emerson, urged America to stop looking to Europe, and to find her own identity instead. There are many solitary characters in American nineteenth-century literature, too; in *Moby-Dick* (one of Pollock's favourite books) a restless Ishmael 'quitely take[s] to the ship' where 'meditation and water are wedded for ever'.

Unlike the Old World Romantic figure, who retreated from society to become lost and overwhelmed in a sublime landscape, the American transcendentalist's retreat was homely and reassuringly manageable. Emerson's contemporary, Henry David Thoreau, for example, lived in a quaint cabin on the outskirts of a town; his mother visited regularly and dropped by with supplies. Thoreau's 'Nature' was a well-managed forest with a pond bordered by long grass.

Pollock's first man hut was a disused chicken coop as an adolescent; his retreat in Long Island in the 1940s would have a similar plain domesticity to it.

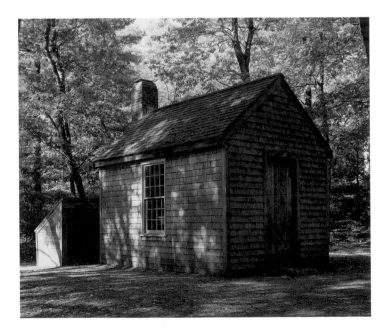

Thoreau's cabin,
Walden Pond, Concord,
Massachusetts.

An American Pantheism

The aim of Thoreau's cosy retreat was to be at one with nature. In the poem below, man and nature are entwined, as the poet's emotional state reflects the passing of the seasons:

> I am the autumnal sun,
> With autumn gales my race is run...
>
> I am all sere and yellow,
> And to my core mellow.
> The mast is dropping within my woods,
> The winter is lurking within my moods,
> And the rustling of the withered leaf
> Is the constant music of my grief...

Echoing Thoreau's assertion, 'I am the autumnal sun', in 1949 Pollock declared, 'I am Nature'. This statement has been repeatedly used to qualify Pollock as a rank egotist or extrovert (despite his psychiatrist's diagnosis of extreme introversion). In fact, Pollock was describing a mode of being. Rejecting the world view that had come to dominate in Europe, which viewed the mind and the natural world as separate entities (inspired by the ideas of the French seventeenth century philosopher René Descartes), Pollock aligned himself with the American transcendentalists, and envisaged a symbiotic connection with the world.

The parallels between Krishnamurti's teachings and the transcendentalists' vision is no coincidence. Thoreau had also been interested in Eastern thought, and had read sacred Indian texts that were being translated and published in America for the first time. In the course of the nineteenth and twentieth centuries American philosophy would continually look to the East for inspiration.

Life with the Bentons

In 1930 Pollock moved to New York, and began sharing a flat with his brother Charles. He also signed up at the Art Students League to study with Thomas Hart Benton, a muralist whose paintings glorified America and its workers. Benton's wife Rita scooped Pollock up and mothered him through his first few years in New York. On account of the delicious spaghetti that she made, Pollock affectionately called her Spaghetti Rita.

The Bentons' life had a very American flavour. On Mondays, for example, they held country music nights; Pollock joined in and played the harmonica rather badly. Pollock also babysat their son T.P., whom he captivated with his stories of an invented character, Jack Sass – a lonely hero who rode through the Wild West discovering abandoned goldmines.

Art Students League

At the League there were two rival groups – Benton and the American Regionalists, who were always arguing with the European school, led by Arshile Gorky and Stuart Davis. Pollock was ferociously loyal to his teacher. For a while Pollock emulated Benton's romantic scenes of America – *Going West* shows a moonlit scene with a lone character leading his cattle through a mountainous landscape. Art critic Kirk Varnedoe argued that the work 'is not so much a landscape as an inscape'. Like the imaginary Jack Sass, the solitary figure journeying into unknown territory bears the imprint of Pollock's childhood, and the challenge of being constantly moved around the West.

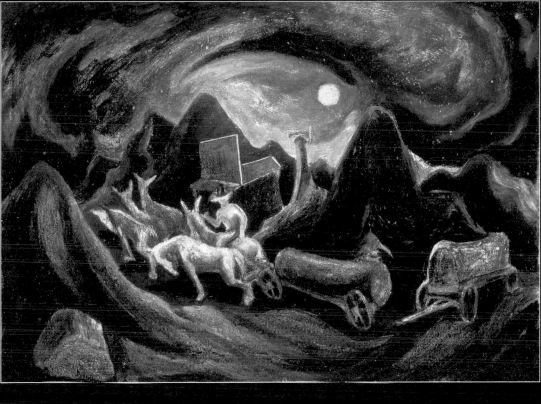

Going West
Jackson Pollock, 1934–35

Oil on fibreboard, 38.3 x 52.72 cm
Smithsonian American Art Museum, Washington, D.C.
Gift of Thomas Hart Benton

A More Dynamic Side to Thomas Hart Benton

Although Pollock would later dismiss Benton's influence, the iconic drip paintings of his mature period, with their vibrant dance-like scrawls, have a raw energy that is similar to that of Benton's large-scale murals. Benton's best-known works are the *America Today* murals, which were a commission for the New School in New York (Pollock was one of the many models). In situ the mural ran from floor to ceiling, and a serpentine rhythm flowed through its figures – many life-size – as its story unfolded around the room. Anticipating Pollock, Benton envisaged mural painting as a field of expressive action. As he explained:

Detail of Thomas Hart Benton's *America Today* murals (1930–31) for the New School. Now part of the collection of the Metropolitan Museum of Art, New York.

> A mural is for me a kind of emotional spree. The very thought of the large spaces puts me in an exalted state of mind, strings up my energies... A certain kind of thoughtless freedom comes over me. I don't give a damn about anything. Once on the wall, I paint with downright sensual pleasure.

All in a Day's Work, 1935–38

After leaving the League, Pollock signed up with the newly formed WPA. The programme treated artists like blue-collar workers: they were not to sign their work, and they had to clock in and finish their jobs on time, otherwise they were fired. Like a factory product, WPA art came in two sizes – 16 by 20 inch or 24 by 36 inch.

From the beginning Pollock failed to comply with the rules; usually still in pyjamas at clock-in time, he struggled to produce the required amount of work. In 1938 he was fired for absence, though he continued to work, off-and-on, for the scheme until 1943. Despite everything, however, the WPA provided a financial lifeline, and gave Pollock the time to explore different things.

In 1936 Pollock volunteered to help at David Siqueiros's Experimental Workshop on Union Square. A revolutionary Communist, Siqueiros used radical techniques, experimenting with industrial paint and spray cans. Anticipating Pollock's signature drip paintings, sometimes he lay his canvases on the floor and dribbled paint onto them.

Pretty negative stuff so far
– Jackson Pollock

In a letter to his brother Charles in 1940, Pollock summed up his New York experience as 'pretty negative stuff so far'. His support system had slowly collapsed over the previous few years, as the Bentons had moved to Missouri, a close girlfriend had left New York and he had been thrown out of the WPA programme. Pollock had started drinking heavily as a result; his brother Sande, who shared an apartment with him at this time, would often find him asleep in the stairwell, or collapsed in the street.

By June 1938 Pollock was being treated for alcoholism at the Bloomingdale Asylum. Sande wrote to Charles to say 'their little brother' was 'afflicted by a definite neurosis' and was 'mentally sick'. Pollock remained at the asylum as an in-patient for four months. When he left, he started seeing Dr Joseph Henderson, a recently qualified Jungian therapist. Realizing that Pollock was not a great communicator, Dr Henderson encouraged him to bring drawings to his sessions as talking points. Versed himself in Jungian thought, Pollock seemed to lead the sessions – almost as if as if he were playing with Henderson. Later, Henderson realized he'd failed his patient:

> I wonder why I neglected to find out, study or analyze his personal problems.... I wonder why I did not seem to try to cure his alcoholism. I have decided that it is because his unconscious drawings brought me strongly into a state of counter-transference to the symbolic material he produced. Thus I was compelled to follow the movement of his symbolism...

Pollock gave 83 of these drawings to his analyst. An untitled drawing inspired by Picasso (page 27) was originally part of Henderon's collection. After Pollock's death, and violating patient confidentiality, Henderson sold the drawings to a gallery. He also gave public lectures and wrote about his famous patient.

While in therapy Pollock continued to drink, and his condition deteriorated further when Henderson moved to San Francisco. One night he stood outside the apartment building of Manuel Tolegian – an old friend from this Manual Arts High School days and a fellow painter. Pollock methodically worked his way through a pile of rocks, smashing every window on the block. Tolegian finishes the story: 'I ran downstairs and beat him up.'

Birth, 1938–1941

In the late 1930s Pollock was drawn to universal themes like birth and death. (His own birth had been traumatic – he had been temporarily choked by the umbilical cord). In *Birth* Pollock presents a violent struggle. It is a cascade of descending circular forms, and perhaps the upside-down face with menacing teeth is a wailing infant emerging into the world. Features like the head with cat ears, the wide female hips and the sinuous Matisse-like arms help identify the mother figure. Like a totem pole, her body exists on the vertical axis. Despite her abstract form, her presence is somehow dominating, reflecting Pollock's feeling that 'mothers are giants'.

This work borrows from both European and Native American art. The amalgamated mouth-nose-eye swirls are like the merged features in Picasso's works, while the hollowed circles, the swirl and vertical teeth look more like the features of an Inuit mask. Pollock had saved an illustration of an Inuit mask and he was fascinated by native North American shamanic traditions. The swirling forms in *Birth* have the frenzied impulse of a shaman's ritual dance, in which the individual is transformed into another being. Pollock biographer Ellen Landau argues that 'we are looking at ... a violent and frightening metamorphosis (not unlike the one Pollock went through himself each time he drank)'.

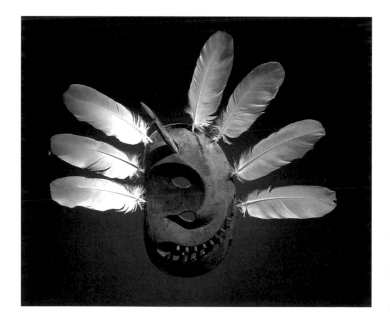

Yup'ik mask, western Alaska, c. 1928.
Wood and feathers. Collected by William Blair Van Valin, Wanamaker Expedition to the Arctic: Nunivak Island/Hooper Bay. University of Pennsylvania Museum of Archaeology and Anthropology.

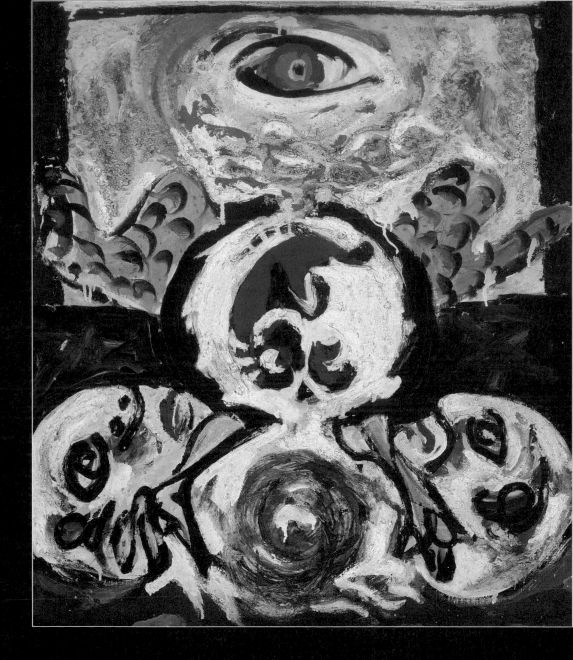

Bird
Jackson Pollock, 1938-1941

Oil and sand on canvas, 70.5 x 61.6 cm
Museum of Modern Art, New York
Gift of Lee Krasner in memory of Jackson Pollock (423.1980)

**We're all of us influenced by Freud, I guess.
I've been a Jungian for a long time.
– Jackson Pollock**

In the late 1930s there was lot of interest in theories of the unconscious; Pollock told an interviewer that he was 'particularly impressed with [the Surrealists'] concept of the source of art being the unconscious'.

Many of the first-generation Surrealists had read the books of Sigmund Freud, who described the unconscious as a personal repository of suppressed desires and memories, usually sexual in nature. When the Abstract Expressionists were emerging, inspiration came instead from Carl Jung. While Jung recognized the existence of a personal unconscious, he also proposed a deeper layer: 'a second psychic system of a collective, universal, and impersonal nature which is identical in all individuals'.

Rejecting the tendency in the West to prioritize individuality and uniqueness, Jung focused on the communal and repeated elements in human experience. The Jungian collective unconscious is composed of archetypes: primordial images or life patterns from our ancestral past that are repeated generation after generation, examples being the wise old man, the child and the mother.

Bird

Occasionally Pollock's work constitutes a more personal reflection on Jungian thought. Diagnosed with a schizoid tendency and a pronounced feminine side, Pollock began Jungian analysis. (Jung believed that through therapy a person can experience a 'psychic rebirth'.)

One can argue that Bird expresses stages in the healing process. At the bottom of the painting the two facing heads can be seen to represent the divided self, with the swirl of dynamic yellow brushstrokes between them signifying a struggle. Perhaps Pollock is pointing to Jungian 'Nekyia', the tumultuous processing of the unconscious before the psyche is reborn and reconciled. The foetal-like structure within an egg implies the synthesis of male and female elements, and is a sign of rebirth, while at the top of the canvas, the centrally placed, vibrant 'third eye' suggests the new enlightened self.

A Father Figure

In 1939, Picasso's *Guernica* – perhaps the most famous anti-war painting of all time – was loaded on to the transatlantic liner Normandie. Leaving behind a wearied Old World on the brink of World War II, the vessel sailed for New York. As the ship approached the harbour, it was as if *Guernica*'s tragic heroine (holding her lamp high) saluted the Statue of Liberty with her torch raised. Picasso's monumental piece was unrolled and exhibited at the Valentine Gallery.

An epic with the immediacy of a daily newspaper, *Guernica* was an epiphany for many New York artists, although Pollock's friend, the art theorist John Graham, had been championing Picasso in America for many years. For William Baziotes, 'Picasso had uncovered a feverishness in himself and is painting it – a feverishness of death and beauty.' Pollock himself made numerous studies of the painting: in *Untitled* Picasso's unruly beasts – the bull and the savaged horse – tangle themselves around each other. Pollock highlights the energy and expressiveness of Picasso's forms.

Pollock would continue to play magpie and borrow from Picasso's repertoire. When he was working on *Guardians of the Secret* (see page 32), he faced the challenge of establishing unity across a massive horizontal field. His solution – with two outer figures framing a core scene – echoes the composition of *Guernica*.

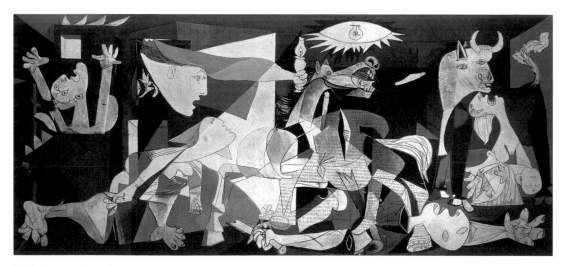

Pablo Picasso. *Guernica*, 1937.
Oil on canvas, 349.3 x 776.6 cm. Museo Nacional Centro de Arte Reina Sofia, Madrid.

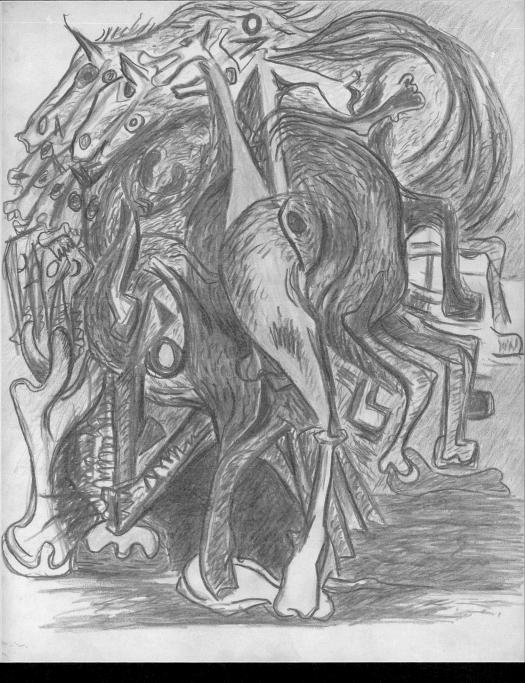

Untitled
Jackson Pollock, c. 1939–42

Coloured pencil and coloured crayon on paper, 35.5 x 27.9 cm
National Gallery of Australia, Canberra (NGA 1986.1049)

John Graham

Pollock said that entering John Graham's home was like entering a temple or a sanctuary; the art critic was a sort of guru figure for Pollock. Lee Krasner remembered Graham as 'a mad, wild, beautiful person'. Graham very much played the part, sometimes greeting his visitors dressed in an Egyptian headdress and ceremonial skirt. The friendship between Graham and Pollock was a strange one, but it worked. Graham even attended one of Pollock's therapy sessions, with Pollock's second Jungian therapist, Dr Violet Staub de Laszlo.

Graham digested theory and distilled its relevance for art. According to the artist Fritz Bultman he was a 'friendly source of Jungian theory for Pollock'. Graham's view was that civilized culture had lost contact with the unconscious and needed 'geniuses' to reveal this rich world – and he was happy to herald Pollock as America's primitive genius. In 1942 Graham included *Birth* in an exhibition he staged at the McMillen Gallery, called 'American and French Paintings'. The show put Pollock on the map.

Lee Krasner

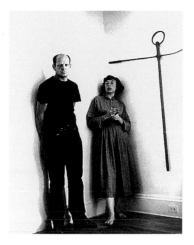

Jackson Pollock and Lee Krasner,
Springs, East Hampton,
New York, c. 1945.

The Russian-American semi-abstract artist Lee Krasner was
also asked to contribute to Graham's exhibition of American and
French art. Before the opening Lee decided to introduce herself
to Pollock: he only lived round the corner, and Lee was curious
as she'd never seen any of his work. 'To say that I flipped my lid
would be an understatement. I was totally bowled over by what I
saw ... I felt as if the floor was sinking when I saw those paintings.'

Pollock had, in fact, very little experience of women. An intense
character, Lee was part of an avant-garde group of painters.
And at this point, she was having more commercial success
than Pollock. When Pollock appeared at her flat to take her up
on an invitation for coffee, Lee took him down to the local diner.
Preocupied with her work, she couldn't cook or even boil a kettle.
However, as their relationship developed, she metamorphized
into a very different being.

She was infatuated. 'I was terribly drawn to Jackson and I fell in
love with him – physically, mentally – in every sense of the word.
I had a conviction when I met Jackson that he had something
important to say. When we began going together, my own work
became irrelevant. He was the important thing.'

As a child Lee had taken 'second place' in her family. According
to biographer Gail Levin, Lee's mother, 'like many other Jewish
mothers favoured her only son over her daughters.' In October
1945, the couple married in a New York church; the church
cleaner stood in as a witness. The energy that Lee once had for
her art, she now used to promote Pollock's career and organize
their home life. She instigated the move to Springs, which
worked well for a while. Pollock was dry, productive and pretty
content. Interestingly, Lee insisted that Pollock stopped seeing his
analyst. In Laszlo's opinion, 'Lee was very possessive so she was
threatened by anyone else on whom he was dependent.'

If Lee acted like an overbearing mother, though, Jackson played
truculent child. Tensions marked their life together. The day
began with Lee smouldering at the kitchen table: 'While he had
his breakfast I had my lunch... He would sit over that damn cup of
coffee for two hours. By that time it was afternoon.'

INDIAN ART OF THE UNITED STATES, 1941

As Pollock wrestled to free himself from Picasso's influence, the Museum of Modern Art (MoMA) opened their exhibition 'Indian Art of the United States'. Native American art was presented as the original source of American culture; curator René d'Harnoncourt even boldly argued that Indian culture was morally superior to Europe's. A fervent nationalism swept through the reviews.

Pollock visited several times, including with his Jungian therapist, Dr Violet Staub de Laszlo, and John Graham.

The Indian sand painter works from the four compass points towards the centre. There is a harmony of elements, where every element has what Pollock would call 'the same amount of interest'.

The forms were familiar to Pollock; he and his brothers had visited the Indian cliff dwellings of America's West. John Graham would undoubtedly have emphasized his idea that Native American art was an avenue for accessing Jung's collective unconscious. The sand paintings and the recreations of several Utah rock art murals, all drawn across a single rock face, were the most impressive pieces, and there were elements in these works that would later underpin Pollock's mature style. In 1947 Pollock would reflect that the working method used for his drip paintings was 'akin to the method of the Indian sand painters of the West'.

The stark field and bold abstract figures of the Utah mural looked modern.

Pollock's late work would have the scale of the Utah mural.

Pollock would start working on the floor like an Indian sand painter.

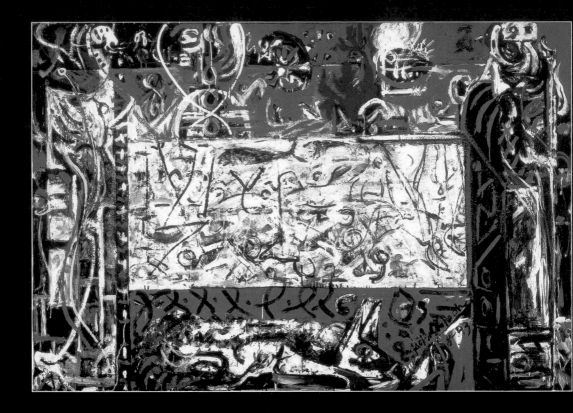

Guardians of the Secret
Jackson Pollock, 1943

Oil on canvas, 122.9 x 191.5 cm
San Francisco Museum of Modern Art
Albert M. Bender Bequest Fund purchase

**The record of all human intercourse is perpetuated
through the medium of symbols.
– John Graham**

In the early 1940s, Pollock engaged with the symbols and visual
syntax of Native American art. In the top panel of *Guardians of
the Secret* there is a fish pictograph, a Tsonoqua mask and a
hunched-over bug (copied from a Mexican pot that Pollock had
seen at the MoMA exhibition). Inside the white rectangle, figures
emerge, which art historian Jackson Rushing has compared to the
graphic matchstick men on a pot made by the Hohokam Indians
of Arizona, and which was also included in the MoMA show.
The Hohokam pot has a very fluid structure, with the figures
navigating their way round the space – some are even upside
down. Most of Pollock's figures in *Guardians* are upside down.

An upturned world suggests the timeless carnival spirit, where
the old established order is turned on its head. While over the
years Pollock's drip paintings have lost their shock value, his
upturned graffiti figures still mock the tradition of European
art and its civilized images of the human body. This primitive
gesture had particular resonance in the post-war years; facing
the dilemma of how to represent man after the Holocaust, German
artist Georg Baselitz would also paint his figures upside down.

The disparate elements of *Guardians* are brought together by the
rigid composition, with the two outer figures framing the interior
scene (echoing Picasso's composition for *Guernica*). But while
Picasso's figures unveil the horror of war, Pollock's guardians
protect an inner world. Like layers of pictographs on Indian rock
faces, the symbols of mankind are timelessly bound together on
a flat surface.

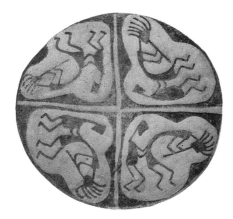

Pottery bowl, Hohokam,
Southern Arizona.
Diameter 27.3 cm.
Collection Gila Pueblo,
Globe, Arizona.

Peggy

In 1941, after 22 years of living in Europe, the outlandish New York heiress Peggy Guggenheim returned home and opened a futuristic museum/gallery on West 57th Street. Fabulously rich, she liked to buy a 'picture a day'.

Peggy was known as much for her sex life as for her art collecting. Despite her infamous 'potato' nose – Pollock supposedly said that you would need to put a bag over her head if you were going to bed her – it was rumoured that she had had more than 1,000 lovers. Once asked how many husbands she'd had, she replied, 'Do you mean mine or other people's?'

In 1943 Pollock submitted *Stenographic Figure* to be considered for Peggy's Spring Salon. Peggy dismissed it, telling the artist (and her intimate friend) Piet Mondrian that the 'young man has serious problems... and painting is one of them'. But Mondrian disagreed, 'I have a feeling that this may be the most exciting painting that I have seen in a long, long time, here or in Europe.' Convinced, Peggy followed up with her usual extravagance, promising a one-man show and a contract with her gallery. She also commissioned Pollock to paint a mural for her entrance hall.

Securing a patron was essential, but Peggy's blithe frivolity gave her a cold edge. As Pollock tackled the meaning of life, Peggy's mind was elsewhere.

Peggy Guggenheim and her collection of glasses, Venice, 1962.

Horror Vacui: *Mural*, 1943

Peggy's friend, the pioneering conceptual artist Marcel Duchamp recommended working up the mural as an easel painting so that it was portable. The arrangement was that it would be finished and in situ, ready for the opening of Pollock's first one-man show at Guggenheim's gallery.

In a letter to his brother Charles, Pollock described the project as 'exciting as all hell'. After knocking down a wall in his apartment to accommodate the size of the canvas (roughly 2.5 by 6 metres), he spent months staring at its blankness. As the date approached, he spiralled into a deep depression and began drinking heavily. Meanwhile Peggy was getting crabby and kept calling. Supposedly the night before the delivery date, Jackson had done nothing; by the next morning Krasner was telling a friend, 'You won't believe what happened. Jackson finished the painting.'

Like the time he laid roads in the Grand Canyon with his dad, working was a release for Pollock. Friend and poet Frank O'Hara identified how 'the scale of the painting became that of the painter's body... Upon this field the physical energies of the artist operate in actual detail, in full scale.'

Pollock's working process is inscribed in *Mural*'s dynamic textures, which entirely fill the surface of the work (*horror vacui* is the fear of empty space). Like a ritual dance, with paint pot in hand, Pollock moved in synchrony with his brush: the graphic figures on tiptoe were executed with a single sweep of the brush. Moving across the canvas, figure after figure appeared in rapid succession, and the turquoise and yellow strokes were layered on top.

Radical Art

The influential art critic Clement Greenberg took one look at the work and decided that Pollock was 'the greatest painter this country had produced'. A Marxist and a dogmatic formalist, Pollock would foreground abstract qualities like line and colour. But *Mural* is far from a clinical analysis of form; it is an explosive piece with rich associations.

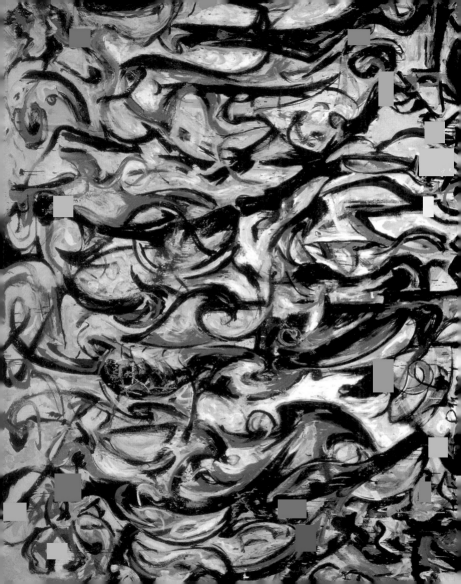

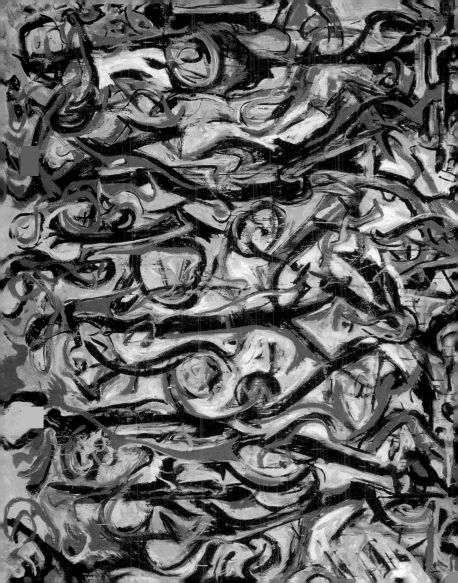

The Hunters of the Plains

The influential critic, painter and poet Henri Michaux declared in 1944 that he had had enough of Picasso's monsters, and that it was time to look for different monsters by different paths. *Mural* certainly delivers on this front. American art critic Irving Sandler wrote that Pollock 'pulverized' Picasso's 'closed forms and scattered them over the surface in curvilinear rhythms'. A seething beast of energy is unleashed – life-sized calligraphic figures charge across the canvas and raw colours riot.

While the span of the canvas has the horizontal pull of the Utah mural (see pages 30–31), the graphic figures are like blown-up versions of the Hohokam hunchbacks (see page 33), who are caught in a surge of energy. Before starting work, Pollock had a vision: 'It was a stampede…[of] every animal in the American West, cows and horses and antelopes and buffaloes. Everything is charging across that goddamn surface.'

As a child Pollock had experienced constant change; the 1941 MoMA exhibition might have reawakened that wandering spirit. The rooms in the exhibition dedicated to 'The Hunters of the Plains' celebrated the freedom and mobility of the 'roving nomads'. The accompanying catalogue argued that the form their decorative arts took was intrinsically connected to their nomadic lifestyle: 'The rapid motion of the horseback riding also encouraged the decorative use of feathers and fringes, which are at their best when stirred in the wind.' In *Mural*, decorative forms propel the impulse. We don't know if Pollock read the catalogue, but he certainly saw the exhibition, which included a cowhide painted with hunters on horseback, tearing across an empty plain after their prey.

In the room the women come and go.
Talking of Michelangelo
– T. S. Eliot

In her usual blasé way, Peggy wasn't at home to receive the mural, and Pollock kept calling her at the gallery. Duchamp eventually helped Pollock hang the painting (and the two men supposedly had to cut 20 cm off the sides of the canvas so that it would fit the space). Meanwhile Peggy's roommate was having a party; nobody was interested in the artwork in the hallway. This cold reception hit a raw nerve; Pollock poured himself a drink, and got drunk.

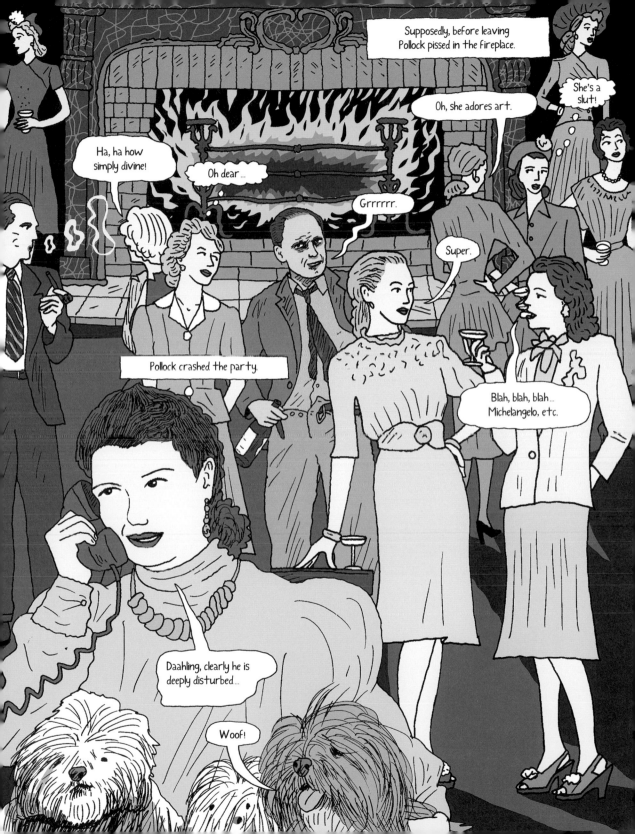

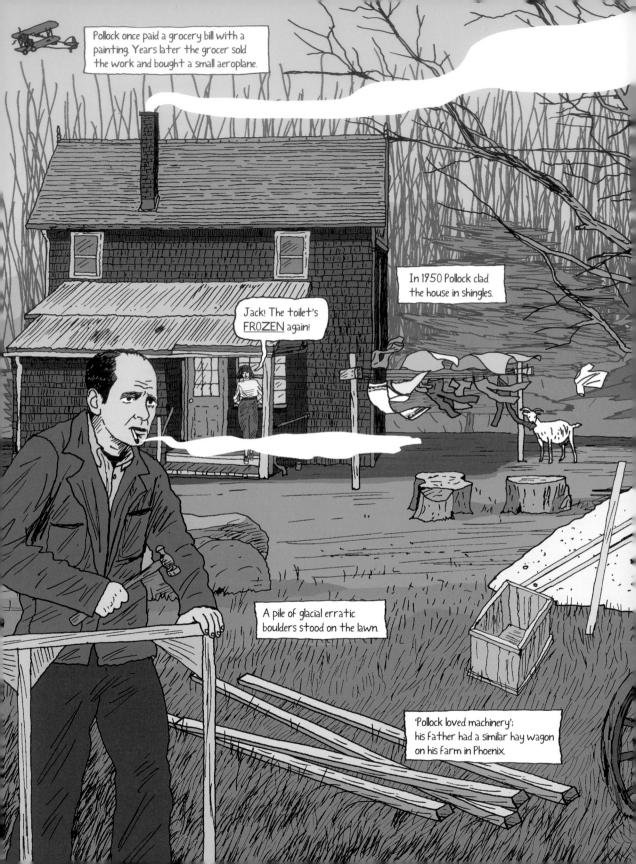

SPRINGS, 1945 TO 1956

In 1945 Lee and Jackson left New York City, and bought a timber farmhouse in Springs, Long Island. There was no plumbing, the only heat was from the kitchen stove, and the first winter was bitterly cold. The newlyweds worked hard overhauling the place. Outside Pollock struck a deal with his wife: 'I'll dig it and set it out if you'll water and weed.'

Pollock converted the old fishing tackle shed into a studio. He moved the building from its original site because it blocked the view of Accabonac Creek from the house.

Pollock named one of his dogs Captain Ahab after the tyrannical skipper in Herman Melville's *Moby-Dick*.

Pollock adopted a friendly crow.

A Comforting Ordinariness

When Krasner told Jackson how much his drinking troubled her, he answered, 'Try to think of it as a storm. It'll soon be over.'

In Springs the storm settled, and there followed a long period of calm. According to Lee, 'From 1948 to 1950 Jackson did not touch alcohol.' Pollock was also seeing a young doctor called Heller, who didn't offer sophisticated analysis, but as Pollock told Lee, 'He is an honest man. I can believe in him.' The glamour of New York faded, and an ordinariness took over their lives; as Lee recalled, 'We cooked, canned, gardened.' Jackson also felt comfortable with the direction his work was taking: 'I had an underneath confidence that I could begin to live on my painting.'

In time Springs would become home to a lively artistic community, but Jackson was happier spending time with the locals. He became friends with Daniel Miller, who owned the local village store. Miller knew that Pollock had left New York 'to get away from the fraud, the foam, and battle the waves himself'. Miller understood that his friend was at heart 'a very, very conservative man'. New York had embraced Pollock as its wild child; in Springs he was just a normal guy.

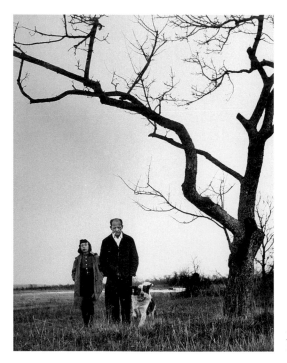

Jackson Pollock and Lee Krasner, Springs, 1949.

The Pantheist Emerges

Springs has a stark, beaten beauty. The low horizon of the flat land clears space for the boundless sky; uninterrupted winds sweep across the wetland. Pollock loved the rough, tousled dunes behind his house, which led to a pebbly beach and the open sea. Lee and Jackson would take long walks on the beach; he relished the views in wintertime, with the snow covering the sand. A friend later reflected: 'The land, the sky, the weather, they were all parts of a whole in which [Jackson] felt as right as he could.'

Pollock found some massive granite boulders at a local site that had been dropped by a glacier during the last ice age. He had them dragged to the centre of his grassy lawn, where they loomed over an otherwise tidy set-up.

Pollock's appreciation of nature was shaped by Jiddu Krishnamurti's pantheistic vision (see page 12). He often talked about Krishnamurti, and many people noted that Pollock's world view was unusually all-inclusive. Sometimes his home improvements felt like a collaboration with nature. Propelling the tidal drift a little further, he decorated his sitting room with bits of gnarled wood, a rusty anchor and pebbles. He also clad his house with cedar, allowing it to blend into its surroundings.

The voice of the transcendentalist is especially relevant to the Springs years: the man hut by grassy waters echoes Thoreau's life by Walden Pond. The way Pollock entwined himself with nature's rhythms has the claustrophobic intensity of Walt Whitman's poetry. 'Song to Myself' provides a great introduction to the Springs canvases.

> The smoke of my own breath,
> Echoes, ripples, buzz'd whispers, love-root, silk-
> thread, crotch and vine;
> My respiration and inspiration, the beating of my heart,
> the passing of blood and air through my lungs;
> The sniff of green leaves and dry leaves...
> The feeling of health, the full-noon trill, the song of me
> rising from bed and meeting the sun.

Reshuffling the Deck

In 1946 Pollock converted the barn into a work studio, and *Shimmering Substance* was painted there. It has that Whitman 'feeling of health, the full-noon trill, the song of me rising from bed and meeting the sun.' An animated field of coloured swirls, and a spring palette of white, canary yellow and cherry red is fresh and cheerful, undoubtedly reflecting Pollock's improved state of mind. It marked a new direction for him.

In a moment of rupture, Pollock reshuffled the deck. Frustrated with previous symbolic modes, the universal subjects, references to archaic art and unconscious symbols all disappear from his painting. *Shimmering Substance* offers a visual testimony to philosopher Marshall Berman's thesis that the physical world has no substance.

The impasto surface of *Shimmering Substance* has a raw beauty. Pollock squeezed the paint from the tube directly on to the canvas, and worked rhythmically, sometimes gouging out the swirling forms with the end of a brush stick. The improvised gestures are free, but in no way arbitrary or accidental, as is often suggested. John Graham likened the painterly gesture to a singer's voice: 'It falls and rises and vibrates differently whenever it speaks of different matters.'

Pollock followed nature's rhythms when he painted, as he described to a local friend. 'Ever try just listening up there at Green River? You can feel what I am trying to say, maybe.' *Shimmering Substance* captures 'the full-noon trill': a warm golden orb bathes us in that distinctive iridescent midday light, while the broken brushwork suggests the optical 'shimmer' that occurs with intense heat.

Peggy's Departure

After World War II, and a quick divorce from artist Max Ernst, Peggy closed her gallery in New York and returned to Europe. She was keen to be rid of Pollock.

The gallery owner Betty Parsons loved Pollock's art, but she too was wary of him. She agreed to represent him on condition that Peggy honoured her contract and paid Pollock's monthly stipend up to the agreed date. In Venice Peggy would watch the price of Pollock's paintings soar.

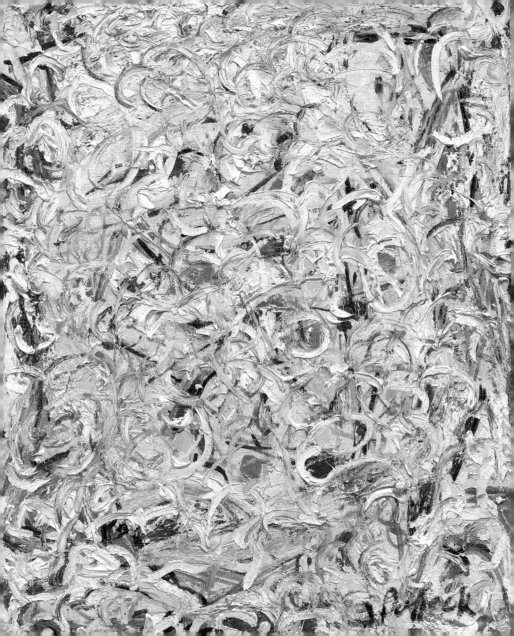

On the Floor

Around 1947, Pollock radically changed the way he worked; the sensuous application of paint in *Shimmering Substance*, which lays bare the working process, anticipated this new direction. Placing unstretched canvas on the floor, Pollock dispensed with traditional oil paint, and started experimenting with household paint – a very liquid substance, which he splattered, dribbled and poured across the surface.

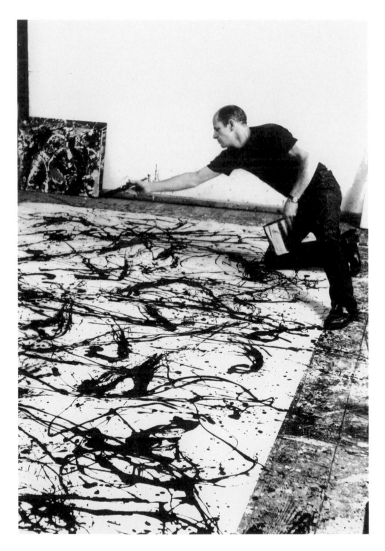

Jackson Pollock at work in his studio,
Springs, summer 1950.

Pollock Speaks

In the winter of 1947–48 Pollock published an article in the art magazine *Possibilities*. Always reluctant to speak publicly, the statement is a precious resource and gives a very lucid account of his new methods. The article was edited by fellow artist Robert Motherwell and the critic Harold Rosenberg.

My painting does not come from the easel. I hardly ever stretch my canvas before painting. I prefer to tack the unstretched canvas to the hard wall or the floor. I need the resistance of a hard surface. On the floor I am more at ease. I feel nearer, more a part of the painting, since this way I can walk around it, work from four sides and literally be *in* the painting. This is akin to the method of the Indian sand painters of the West.

I continue to get further away from the usual painter's tools such as easel, palette, brushes, etc. I prefer sticks, trowels, knives and dripping fluid paint or a heavy impasto with sand, broken glass and other foreign matter added.

When I am *in* my painting, I'm not aware of what I am doing. It is only after a sort of 'get acquainted' period that I see what I have been about. I have no fears about making changes, destroying the image, etc., because the painting has a life of its own. I try to let it come through. It is only when I lose contact with the painting that the result is a mess. Otherwise there is pure harmony, an easy give and take, and the painting comes out well.

DELUXE NOISELESS

The Dripper Emerges

In his published statement Pollock mentions 'dripping fluid'. He has come to be defined by that provocative drip. For a moment the 'drip' freefalls through the air and the artist loses contact with his medium. In a culture obsessed with the individual, which views mark-making as the signature of authenticity, that freefall is challenging. Is it chaos? A childish mess? Even Pollock himself felt the need to ask, 'Is this a painting?'

Astral Beauty

In *Reflection of the Big Dipper*, shiny black enamel paint has been dripped on to an exuberant field of stained colour. Sometimes the line is lean and propels itself through the field, and other times it pools into a dark, inky splatter. The title evokes the cosmos, and the patterns of stars in the night sky.

The experience of boundless space resonated for Pollock. He identified with Springs' open ocean and the expansive landscape of the West. During an interview with William Wright for WERI radio in 1950, he described the need for artists to express the aims of the age that they live in, and singled out 'the airplane, the atom bomb, the radio' as symbols of his age. A few years later, social theorist Marshall McLuhan would describe the transformative effect of electronics, which he felt dissolved frontiers, and located man in a vast and infinite world.

A sense of tragedy can also lurk in the experience of infinite space; talking about Pollock's *Galaxy* (painted in the same year as *Big Dipper*), art historian T. J. Clark described 'an unapologetic emptiness, like a glimpse into deep space'.

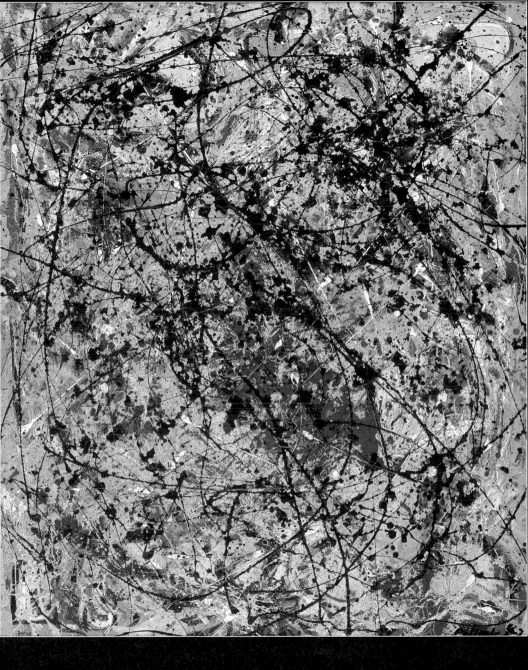

Reflection of the Big Dipper
Jackson Pollock, 1947

Paint on canvas, 111 x 91.5 cm
Stedelijk Museum, Amsterdam. Gift of Peggy Guggenheim (A2971)

Night Vision

When Jackson couldn't sleep, he would take a walk in the nearby forest or along the pebbly beach. In darkness, vision is impaired and other senses are heightened – we 'feel our way', and noises that we wouldn't normally register seem to reverberate. If *Shimmering Substance* evokes the full noon trill, *Full Fathom Five* is a night-time piece: the orange and yellow pierce the dark field like sounds in the dark. Embedded in the tar-like encrusted surface are tacks, a key, paint tube tops and some cigarettes.

Undoubtedly Pollock's reference is Picasso, who incorporated everyday materials into his collage. However, Picasso's 'things' exist in a taut Cubist framework, while Pollock's bits and bobs are part of a dark, swirling mesh, suggesting that feeling of groping in the dark.

The challenge of Pollock's art lies in its radical 'all-over' composition. The spectator is offered an adventure – they can follow a pattern, and then change at will to explore a new rhythm. One critic scorned the fact that there was no 'beginning, middle or end' to Pollock's work. Pollock felt the criticism was a compliment: 'My paintings do not have a centre but depend on the same amount of interest throughout.' This offers a stark contrast to the Renaissance perspectival system, where the viewer's attention is focused on a central vanishing point. Following the logic of the Native American sand painters, harmony was created in Pollock's work by balancing elements.

Pollock also used periods of reflection in his painting process. Standing a canvas up against the wall, he would observe it for a while and fathom its effect. He would then lay it flat again and resume painting.

Pollock by Panel

Pollock's all-over paintings ruffled a few feathers. What were they about? What was their purpose? In autumn 1948, *Life* magazine brought a group of distinguished thinkers around a table to pontificate on the merits of modern art. Pollock's *Cathedral* was a focal point for their discussion. Amidst the banter and catty criticism, the only person that defended the artist was Clement Greenberg.

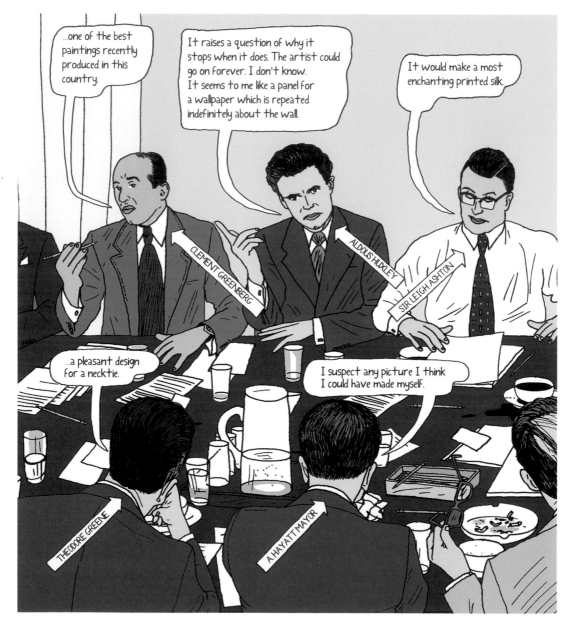

Number 1A, 1948

For a while Pollock dispensed with titles and numbered his canvases. As Lee commented, 'Numbers are neutral. They make people look at a painting for what it is – pure painting.' His seemingly abstract configurations can be daunting. For the artist Helen Frankenthaler they represented a foreign landscape that she felt compelled to enter – 'I *had* to live there.'

Pollock started using his drip technique on a much grander scale. Measuring 1.7 by 2.6 metres, *Number 1A* is impressive. In his easel painting the drips were created by a wrist movement; now his whole body was involved. Later photos and films would show Pollock – a gauche bear of a man – transformed into a graceful soul that darts, crouches and tiptoes round his canvas. He doesn't make a wrong move.

This performance was indelibly recorded on the surface of the canvas. Exuberant and open (with the bare canvas showing through), the impact of this painting does not diminish over time. The marks have a range of textures: they run free, meander and circle in on themselves. Meanwhile the surface silver paint creates a phosphorescent glow: the lines seem to hover in front of the canvas, where they oscillate like they do in *Shimmering Substance*.

Historians tussle over the meaning – whether it lies in the action of painting or its optical beauty. Pollock's legacy has reinforced the division, since he influenced two very different camps of artists. While the Post-Painterly Abstractionists were interested in Pollock's exquisite line, the Performance artists of the 1960s engaged with (and evolved) the dynamic performance of the painting process.

In Pollock's hands, form and performance were never separate. The picture on the wall expresses the bodily experience of the performance. Pollock's relationship with his work was like a dialogue. When asked how he knew a painting was finished, he replied, 'How do you know when you're finished making love?' As he told a friend, he even caressed his work; in *Number 1A* there are tactile passages where paint has been rubbed on with a rag, while around the edge of the painting his presence is recorded with a series of handprints, ranging from pink to dark maroon.

As John Graham recognized, Pollock's gesture also has the sensuousness of a singer's voice. Pollock felt that his art 'should be enjoyed just as music is enjoyed'. Interestingly, he was a fan of New Orleans jazz.

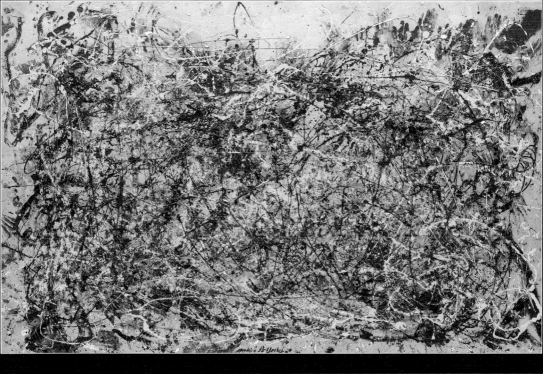

Number 1A
Jackson Pollock, 1948

Oil and enamel paint on canvas, 172.7 x 264.2 cm
Museum of Modern Art, New York. Purchase (77.1950)

MARABAR CAVES

With the volume up full, often playing the same record on repeat, Pollock's sitting room was like the Marabar caves in E. M. Forster's novel, *A Passage to India* – an echo chamber vibrating with sound.

Pollock, an outsider, identified with Black America's greatest indigenous musical form, jazz. In contrast to the preppy flavor of American pop – the likes of Bing Crosby, Dinah Shore and Perry Como – his favourite New Orleans jazz was wild. Its improvised trumpet solos and the raspy voices of Louis Armstrong and Billie Holiday opened up his sober, suburban life to drunken memories of sozzled nights in Greenwich Village bars.

Pollock had a copy of Louis Armstrong's 'Lazy River'. The tempo oozes as it transports the listener down the river. Breaking up the original song, with 'ohs' and 'mmms', Armstrong's performance was central to the meaning of the work for Pollock. Armstrong inhabits the story, conversing with that 'dog' of a river, while he chats with his band, and colludes with the listener – 'Boy, I am riffin' this evening'.

Perhaps Pollock identified with Billie Holiday's struggle with addiction. He owned a 78 of '(I Got a Man Crazy for Me) He's Funny That Way', in which Holiday sings of a devoted lover pursuing her West; perhaps it reminded him of his mother and father's cat-and-mouse chase around the West.

Pollock was given a Charlie Parker record. He hated it. He didn't identify with 'modern' jazz.

The Paradox of *Summertime (Number 9A)*

Pollock's art shares both the visceral quality and emotional range of New Orleans jazz. Art historians have linked his work to bodily functions – for example, the dripping technique is often associated with the act of peeing (Pollock's father apparently showed him how to draw with his urine on the Grand Canyon rocks). Kirk Varnedoe compared his work to the sexual act, due to its 'horizontality and the impulsion of fluid'. Pollock's art is all these things and more – it deals with the full gamut of human experience. Helen Frankenthaler's feeling that she 'had to live there' is what it is all about. Like improvised jazz, Pollock's art is immersive. Jump in and see how it unfolds.

Summertime has an unusual format for Pollock. Long (over 5.5 metres) and thin, it has a strong horizontal impulse. Like a monumental visual score, the black weave is free but directed, while the coloured accents of yellow and red add warmth, like the solo instrument that weaves in and out during a jam. The mood is upbeat, like Count Basie's 'One O'clock Jump', another record in Pollock's collection – one that was intended to get everyone dancing.

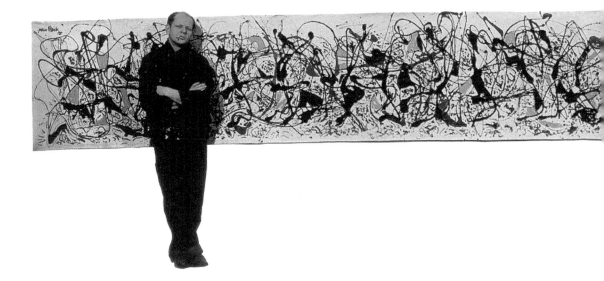

'Jackson Pollock: Is He the Greatest Living Painter in the United States?' – *Life*, 8 August 1949

Standing in front of *Summertime*, sullen, arms crossed in front of him, cigarette in his mouth and ready to blow smoke in your face, Pollock contradicts the vibrant, joyful impulse that unfolds behind him. Why the attitude?

The photo was taken by Arnold Newman to accompany a celebratory article that positioned Pollock as the country's 'greatest living artist'. A turnaround from the smug disdain of *Life*'s earlier round-table discussion, Pollock was, nevertheless, right to be circumspect. The mythmakers were busy branding him as the downtrodden American artist – a powerful archetype that would be adopted by the Beat generation, and later utilized in the powerful propaganda of the Cold War. Art historian Serge Guilbaut has unpicked how, during the McCarthy Communist witch hunts, the government promoted the free forms of modern jazz and Abstract Expressionism in order to project America as a liberated nation.

For Pollock the article was a double-edged sword: he hated exposing himself, yet he also craved acceptance. For years a stack of this issue of *Life* magazine sat on his kitchen shelf, and he relished showing it to visitors.

Pollock posing in front of
Summertime (Number 9A), 1948
Oil, enamel and commercial paints on canvas, 84.8 x 555 cm.
Tate, London. Purchased 1988 (T03977)

Seasons Change: *Autumn Rhythm (Number 30)*

In his gravelly voice, Pollock opens a short film made by Hans Namuth with the words, 'My home is in Springs, East Hampton, Long Island.' At 'home' he had been dry, and highly productive, for two years. In his sealed studio, the only light was from the rafter windows and everything was quiet. Painting was a solitary activity and Lee was wary of interrupting him.

Pollock had first met Namuth in July 1950, when the photogapher approached him with the idea of taking pictures of him at work. Somewhat reluctantly, Pollock agreed to let him record the evolution of his next painting, *Autumn Rhythm (Number 30)*. Returning every weekend, Namuth shot over 500 photographs, capturing Pollock's nuanced movements, and the layers of drips.

Namuth's photos are both a brilliant resource and a piece of art in themselves. Biographer Pepe Karmel argues that Namuth was uniquely equipped to capture Pollock's ritual-like performance, having photographed Mayan rituals and snapped 'actual shamans on his 1947 trip to Guatemala'. However, herein also lay the insensitivity – for the MoMA exhibition in 1941, the Native American sand painters refused to be photographed, believing that this would rob their souls of the ritual. Theorist Susan Sontag endorses this position: 'to take a photograph is to participate in another person's mortality, vulnerability, mutability'.

Pollock once compared himself to a clam without a shell; with the precision of a scientist, Namuth dissected the mollusc.

The Painting

Namuth's photos represented a whole new way of documenting the artistic process. An interesting contrast can be seen, for example, in the photos that Dora Maar took of Picasso's working process for *Guernica*, around a decade earlier – Maar's photos hardly ever feature Picasso. In Namuth's photos, however, Pollock is always in the frame – sometimes a full-body view, sometimes a headshot. We come to seek him out as the recognizable, human element, and find meaning in his very presence, which distracts from the splendour and richness of the work.

The last of the monumental drip paintings, *Autumn Rhythm* sings. A perfect orchestration of the 'all-over' technique, no area is allowed to dominate and the fluid passages are balanced. Despite the massive scale of the painting (measuring about 2.6 by 5.2 metres), the experience is intimate. Like a poet savours words, Pollock loves paint. A minimalist, he limits his palette and lets a few elements reign, exposing their intrinsic qualities. The rough, unprimed canvas, soaked-in black stains, and the sprays of powdery white are a sensuous pleasure.

Pollock is not interested in illustrating an idea, but his handling of paint somehow evokes the 'rhythm of autumn'. The ochre canvas and the squiggly tan drips have the warm, mellow glow of the twilight season. The richness of the work lies in its flowing and ambiguous associations: the tan V-like strokes might suggest birds in flight or dancing figures – whatever the case, they move gracefully through the field. Often the associations work viscerally; at the lower left, the white line unfolds with the sinuosity of a Matisse line, and suggests that satisfying feeling of arching one's back.

Although Pollock battled with depression, his drip paintings are life-affirming. They capture the essence of experience, from the colours and gnarly textures of the night to the astral beauty of the cosmos. Manifesting the fruits of his career, *Autumn Rhythm* is a poignant title for his last great drip painting.

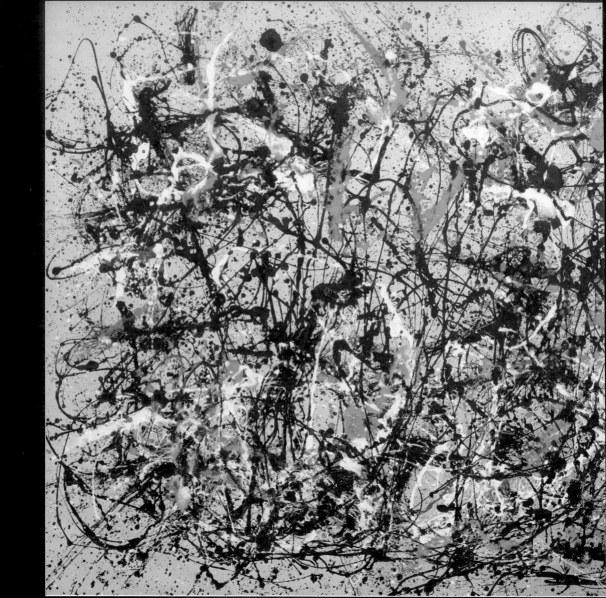

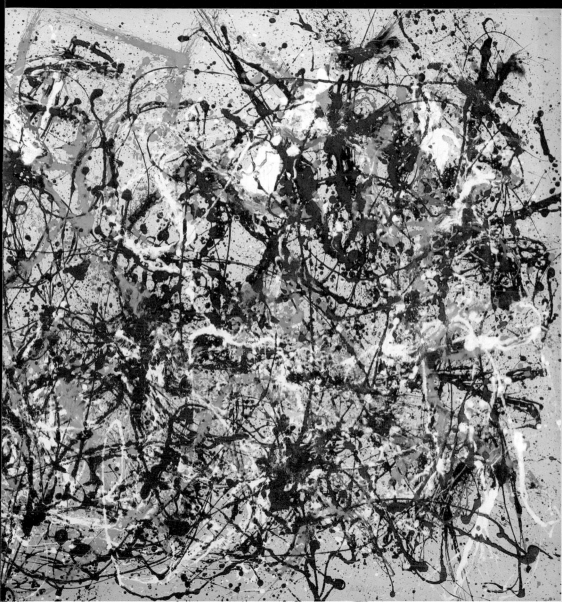

Overexposed

Despite having shot 500 photos, Namuth was frustrated: the light wasn't great in the studio, it was impossible to get a full-face view of Pollock while he was working, and the stills, many of which are blurred, failed to capture Pollock's dramatic movement. Namuth wanted to make a film. Despite the fact that Pollock only ever worked in his cocoon-like studio, Namuth convinced him to paint a canvas in the open landscape.

It was a cold day. The wind was blowing hard, the long grass was in the way, and the paint blustered around. Filming was a tedious process with many re-takes. Once again Namuth wasn't satisfied with the results. He had another idea: Pollock painting on glass. Suspending the glass over a pit (which he filmed from), he was able to get right up close to the action.

Namuth sensed that Pollock was 'very nervous and very self-conscious' – a feeling that he perhaps managed to nail with one particular shot, a full view of Pollock's face while he worked. The man who compared himself to a clam looks like a specimen on a petri dish.

Pollock's Viewpoint

At the start of the film Pollock strokes the surface of glass; he always had a period 'getting acquainted' with his medium. The cold, transparent glass must have felt very different to rough, unprimed canvas.

Pollock's viewpoint was very different to Namuth's: he looked down into a black hole, and the camera bore into him. Under such scrutiny, it was hardly surprising that he felt self-conscious. Pollock explained: 'I lost contact with my first painting on glass and I started another one.' After rubbing out his first attempt, he began by adding bits and bobs – wire mesh, some pebbles and some bits of string. After a while he started painting, but Namuth kept stopping and starting him. Pollock lost his rhythm.

Coffee will be served in the living room
– Lee Krasner

At sunset Namuth called a wrap – perhaps he had what he wanted. Pollock and Namuth headed back to the house. Lee had friends over, and to celebrate the end of filming she'd prepared a feast. Pollock walked into the kitchen and poured two tumblers of bourbon, calling out to Namuth, 'Come have a drink with me'. Lee and her guests watched in silence as he downed his first drink in two years. Then, Pollock started ranting at Namuth, calling him a 'phony'. Holding the edge of table, he goaded his visitors before tossing the table over, and sending the roast dinner and crockery rolling.

As the dogs scurried amongst the broken shards of china, lapping up the gravy, Pollock stormed out the house, got into his car and drove off.

Pollock lost his way after this. Fragile and often drunk, he never regained his focus. For a few years he struggled to produce second-rate work, and then he stopped working altogether. It is significant that his breakdown coincided with the end of Namuth's film – it had been a penetrating examination, his method had been stripped bare and he had lost his confidence. A friend's view was that 'deconstructing the process of making one of these paintings turned him into a cliché.' But other factors contributed to his decline, too, including the death (in a car crash a few months before the filming) of Dr Heller, who had been a great support to Pollock.

Pollock was also a vulnerable character, living in fraught times. The press constantly reported the threat of nuclear war, while McCarthyism had developed into a national hysteria. Society had become oppressively conservative and buttoned down. Biographer Evelyn Toynton points to the cosy endorsement of the American way of life by the much-favored artist Norman Rockwell. She describes one of his front pieces for *Saturday Evening Post*, in which 'Grandmother places the Thanksgiving turkey on the table around which the whole smiling family is assembled.'

Pollock had had enough of performing.

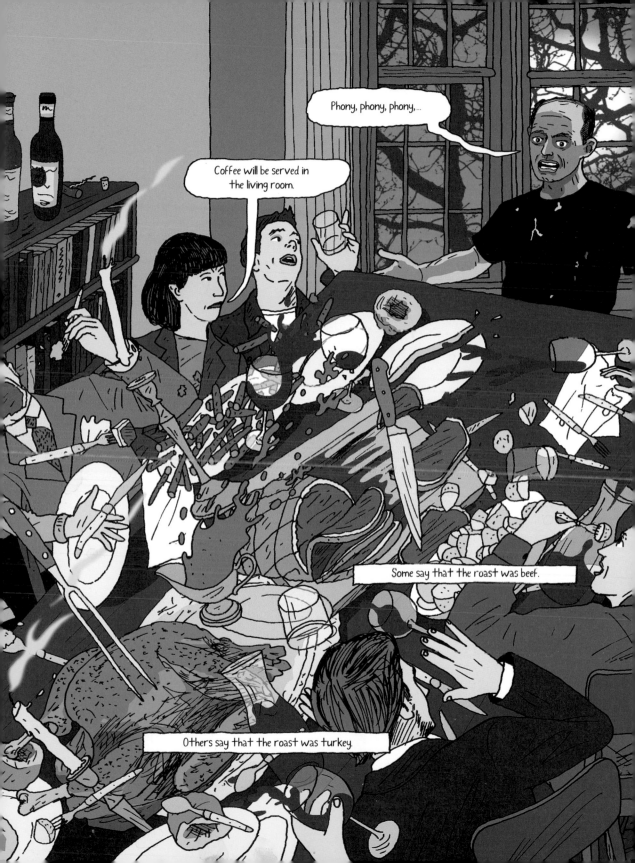

Success and Glamour

On 28 November 1950, Pollock's fourth solo show at the Betty Parsons Gallery opened and New York's fashionable crowd stormed the place. *Autumn Rhythm* took up the entire end wall; one visitor felt the experience was like 'walking into a meteor shower'. Despite the buzz at the opening and the favourable reviews, only one painting sold – the delicately toned *Lavender Mist*.

Following the show, the iconic fashion photographer Cecil Beaton used *Autumn Rhythm* in a fashion shoot for *Vogue*. The painting provided the colour scheme: the glossy black was picked up in the model's silky black cocktail dress, while the lighter tones were brought out in her accessories – the sash, ruffle and make-up.

A high-profile shoot in *Vogue* with a top fashion photographer had the potential of raising interest and sales for Pollock, who was now struggling financially. The photos are stunning, but they are also problematic. As with Namuth's film, the rich, immersive art experience – the meteor shower – drains away, and the painting functions as nothing more than background decoration, fulfilling Huxley's smug view that it should be 'wallpaper which is repeated indefinitely around the wall.'

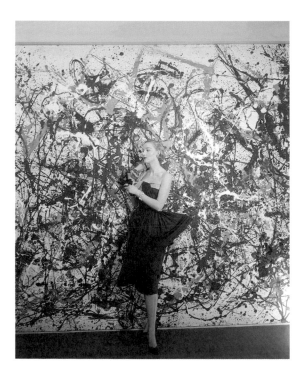

Cecil Beaton's fashion shoot for *Vogue*, with Pollock's *Autumn Rhythm* as a background, 1950.

NYC is brutal
– Jackson Pollock

Pollock and Lee stayed in New York during the Parsons show, and did not return to Springs until the following May. City life did not suit Pollock at all. In a letter to fellow Abstract Expressionist Alfonso Ossorio in January he wrote, 'I really hit an all time low – with depression and drinking – NYC is brutal.' He started seeing a new therapist, Dr Ruth Fox, who specialized in the treatment of alcoholism.

In his vulnerable state, Pollock was exposed to the promises of quacks. In an attempt to cure his alcoholism, he drank a milky concoction called Grant Mark's Emulsion. This was a formula that had been invented by a New York chemist, which was said to deliver 'total well-being'. Lee, too, vested hope in this costly liquid, which she measured out religiously morning and night. Later Pollock reflected, 'I feel I have been skinned alive.'

Back in Springs, Pollock would commute into the big city every Monday to pick up fresh supplies of Grant Mark's Emulsion, and to see his counsellor. When these jobs were done, he would head to the Cedar Tavern.

Total
Well
Being

Cedar Tavern

Pollock's New York life at this point centred around the Cedar Street Tavern on University Place, where other Abstract Expressionist painters, and later the Beat poets, hung out. The drinks were cheap, and the vibe was loose and macho. Lee Krasner said that women were 'treated like cattle'. She hated the place. Things often did get out of hand: Pollock was banned for wrenching the toilet door off its hinges, as was Beat hero Jack Kerouac for pissing in an ashtray.

A friend once said that outside the bar Pollock was a teddy bear, but inside he was a grizzly bear. Wanabee artists crowded round Pollock at the tavern, wanting to be 'touched' by the master, while tourists gathered hoping to see some bad behaviour. The grizzly bear often satisfied his audience, and so the tales of table tossing, physical tussles and drunken rants began to appear.

Tamar Yoseloff in her poem 'Cedar Nights' evokes the atmosphere of this legendary bar and its angst-ridden celebrities:

> Kerouac baptised the ashtray with his piss,
> Rothko gazed into his glass, lost
> in a haze of smoke (later he would slit
> each arm, two razored lines, maroon on white),
> while Gorky picked a fight with every stooge...
> And Jack? He was painting up a storm,
> (when he was sober), admiring his fame
> from the summit of the Gods, until the night
> she breezed into the Cedar, all ass
> and attitude, looking for a guy...

A Change of Gallery

Betty Parsons saw herself as a visionary enthusiast: 'I never pushed sales very hard. Most dealers love the money. I love the painting.' Her 'passion' was pretty useless to Pollock, who remained penniless; in 1952 he decided to move to Sidney Janis's gallery. Although Pollock was becoming more and more famous, Janis did little better for him, although admittedly it was difficult to plan exhibitions when Pollock was struggling to produce new works.

The Story of *Blue Poles*, 1952

Pollock's longtime friend, the sculptor Tony Smith, tried to help Pollock get back into painting:

> We were drinking. We decided to paint something together. I wanted to get him out of himself and into colour again... Jackson was using glass tubes filled with paint. They were basting tubes, with rubber bulbs on one end and about an eighth-of-an-inch opening. But he was gripping the bulbs so hard – because he was in this state – that they clogged. He would throw them down and they would break. So he broke them all.

According to Smith, they returned to the studio a few weeks later; this time painter Barnett Newman joined them. Controversy has always surrounded the painting *Blue Poles*, regarding the extent of Newman and Smith's help. Newman's comment 'my *blood* was in that painting' fuelled speculations that he painted the blue poles, but Lee dismissed this story as 'hogwash'.

Clement Greenberg didn't rate Pollock's late work. The poles that run the course of *Blue Poles* are like pieces of broken scaffolding, a prop to the background painting that lacks the grace and rhythm of his earlier work.

That Place Called Home – Springs

Pollock's erratic behaviour was now alienating friends. He would drive over to see the art critic Harold Rosenberg, who lived nearby in East Hampton, and just stand on his lawn and rage, 'I'm the best fucking painter in the world.' His relationship with Lee also deteriorated as they stepped up their roles, she playing mother and he behaving like a cross child. Meals often ended up in a deadlock with Pollock refusing to eat his dinner. Pollock could be very cruel too. At parties he would shout out, 'Look at the face I'm married to.' Lee retreated.

Most people stepped past the village drunk, a few loyal friends tried to help, and others kept their eye on the valuable assets. After Pollock crashed his first Oldsmobile 88, gallery owner Martha Jackson came to visit him in her fabulous green 1950 Oldsmobile convertible. She left after swapping the car for two of his 'black' paintings. Then there was the village rafffle. Pollock, 'a local artist', was called upon to donate a painting as a prize. Lionel Jackson of East Hampton won the Pollock.

Portrait and a Dream

Portrait and a Dream is one of Pollock's last paintings, and it is a confused amalgam of two very different styles. A representational head sits beside a linear design. Kirk Varnedoe likened it to a 'cartoon figure and a thought bubble'. Perhaps in some way Pollock had absorbed Namuth's film, and the fashion shoot that had 'livened' up his work by placing it beside a glamorous figure; here he substitutes his angst-ridden face.

Final Fling

In 1955 Pollock met the very beautiful Ruth Kligman. Their first encounter is described in the poem 'Cedar Nights' (see page 70), where she is the unnamed woman ('all ass and attitude') who breezes into the Cedar Tavern and searches out the famous painter. Ruth wanted to be a painter; perhaps she thought that being with Pollock might help her career. The common story is that the wild boy betrayed his wife, and hooked up with a pretty, young thing. By this point, though, Lee and Jackson's relationship, as one friend tells, 'wasn't that cute.'

Biographer Deborah Solomon argues that Pollock functioned in terms of Freud's 'privileged person', an exceptional character who is expected and allowed to break social mores. But was this priveleged person really that privileged? The gutter press projected every escapist fantasy on to Pollock, and then luridly documented his decline. Pollock was loose and high, but as greengrocer Daniel Miller puts it, 'What did he do? Just the same as generations for hundreds of thousands of years – he turned to women and alcohol. It's been done a million times. That's basic – there's nothing new in that reaction.'

The affair was no solution. Pollock came up with the idea of living with both Lee and Ruth. That wasn't going to work. Lee left for Paris and left Ruth to struggle with Pollock in his depressed state.

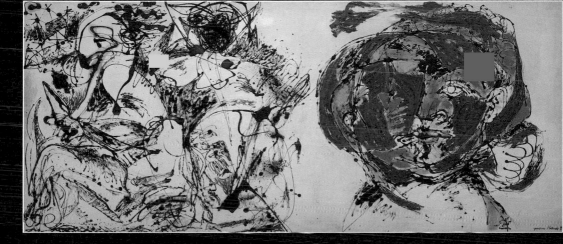

Portrait and a Dream
Jackson Pollock, 1953

Oil and enamel on canvas, 148.5 x 342.2 cm
Dallas Museum of Art
Gift of Mr. and Mrs. Algur H. Meadows and the Meadows Foundation, Incorporated (1967.8)

Waiting for Godot

Impressionist painter Edgar Degas once said, 'It is the movement of people and things that distracts and even consoles, if there is consolation for one so unhappy. If the leaves of the trees did not move, how sad the trees would be and we too!'

Pollock found movement comforting. In the early years of Springs, lithe and mentally focused, he 'lived in his painting', and his creative process was a graceful, rhythmic performance. Jazz was another pleasure; Lee describes the house 'rocking and rolling for days', but the new jazz disrupted the groove of the New Orleans sound.

In the spring of 1956 Pollock went to see a Broadway performance of Samuel Beckett's stark existential play, *Waiting for Godot*. Impressed by its abstract form, he considered it 'the most

important play', yet emotionally he couldn't manage it. He tried three times to see it. Ruth Kligman described the last attempt: 'He started to cry, really cry, and then the crying turned to sobs and then it went into heartbreaking moans.... His eyes were closed. He was lost, not realizing we were in the theatre.'

The play revereberates with a paralyzing inertia, reflected in the character Estragon's first utterance, 'Nothing to be done'. There's no distraction, or consolation. Pollock dissolved at the point where Lucky enters on a long leash, weighed downed by luggage – perhaps the sight of Lucky throttled at the neck reminded him of his own birth and being choked by the umbilical cord. Ruth pulled him out of the theatre.

'Rage, rage against the dying of the light'

On the evening of 11 August 1956, there was a party at Alfonso Ossorio's house. Pollock, Ruth and her friend Edith Metzger piled into the Oldsmobile. In the afternoon Edith snapped Ruth and Pollock sitting on one of the glacial boulders that stood on his lawn. Pollock looks pretty drunk.

En route, Pollock decided that he felt too lousy to go, and turned back. Agitated, he was driving very badly and the girls were scared. Edith's screams irritated him, and he flattened the accelerator to the floor, lost control on a sharp corner and smashed into two young elm trees. Pollock died instantly. Edith was also killed. Ruth survived the accident but suffered serious injuries.

This story has been told many times before. The final fuel for the cowboy mythology, his death has been read as the 'ultimate image of recklessness'. Ruth thought it was destiny, 'a romantic way to die'. Others were more reticent. When Lee asked Clement Greenberg to give the eulogy at the funeral, he refused. He didn't want to speak about 'this guy who got this girl killed'. No eulogy was given.

Pollock is buried in Green River Cemetery. The headstone is a 15-tonne boulder, chosen to match the glacial boulders that stood in his yard, which he'd always meant to make into a sculpture. Near the massive rock is a smaller boulder – Lee Krasner's headstone.

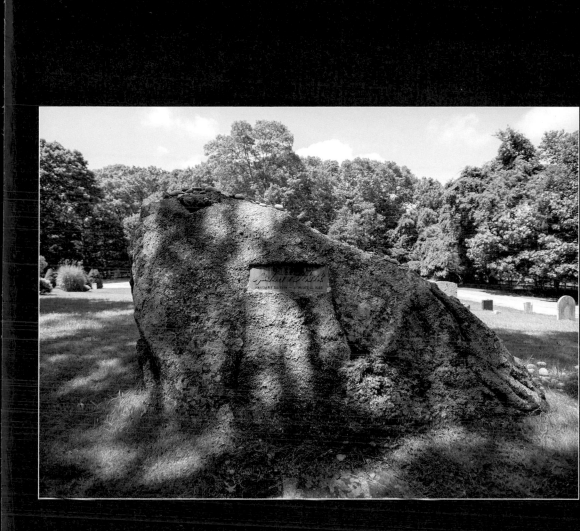

Jackson Pollock's boulder tombstone,
Green River cemetery.

Acknowledgements

For Matthew with love.

A heartfelt thanks to Laurence King for taking on this nutty project, and Donald Dinwiddie for his cheerful helmanship, and all the work he put into this book. I am extremely grateful to Angus Hyland for his creative vision, Jo Lightfoot for her support, Julia Ruxton for sourcing such great images and Melissa Danny for being so wonderfully patient and optimistic in the early stages of the project. A big thanks to fellow Scot Peter Arkle for his fantastic images.

I would like to thank my mum and dad for their support over the years. Much love to Lulu and Sam.

Catherine Ingram, 2013.

Bibliography

Beckett, Samuel. *Waiting for Godot*. London: Faber andFaber, 2006.
Berman, Marshall. *All that is Solid Melts into Air: The Experience of Modernity*. London: Verso, 2010.
Guilbaut, Serge. *How New York Stole the Idea of Modern art: Abstract Expressionism, Freedom, and the Cold War*. Chicago: University of Chicago Press, 1983.
Harrison, Helen, ed. *Such Desperate Joy: Imagining Jackson Pollock*. New York: Thunder's Mouth Press, 2000.
Jung, Carl G. *Man and his Symbols*. New York: Random House, 1968.
Karmel, Pepe, ed. *Jackson Pollock: Interview, Articles, and Reviews*. New York: Museum of Modern Art, 1999.
Landau, Ellen. *Jackson Pollock*. New York: Abrams, 2005.
Levin, Gail. *Lee Krasner: A Biography*. New York: Abrams, 2011.
Melville, Herman. *Moby-Dick*. New York: Penguin, 2003.
O'Hara, Frank. *Jackson Pollock*. New York: George Braziller, 1959.
Phelan, Peggy. 'Lessons in Blindness from Samuel Beckett', in *PMLA* (*Publications of the Modern Language Association of America*), vol. 119, no. 5 (October 2004): 1279–88.
Polcari, Stephen. *Abstract Expressionism and the Modern Experience*. Cambridge: Cambridge University Press, 1993.
Pollock, Sylvia Winter, ed. *American Letters 1927-47: Jackson Pollock and Family*, Cambridge and Malden, MA: Polity press, 2011.
Solomon, Deborah. *Jackson Pollock: A Biography*. New York: Cooper Square Press, 2001.
Sontag, Susan. *On Photography*. New York: Penguin Classics, 2008.
Yoseloff, Tamar. *The City with Horns*. Cromer: Salt Publishing, 2011.
Toynton, Evelyn. *Jackson Pollock*. New Haven: Yale University Press, 2012.
Varnedoe, Kirk and Pepe Karmel, eds. *Jackson Pollock: New Approaches*. New York: Museum of Modern Art, 1999.
Whitman, Walt. *Leaves of Grass*. New York: Penguin, 1986.

On page 70, the lines from 'Cedar Nights' are courtesy Tamar Yoseloff and Salt Publishing.

Picture Credits

Catherine Ingram is a freelance art historian. She obtained a First Class Honours degree at Glasgow University, where she was a Honeyman scholar. After an MA in 19th-century art at the Courtauld Institute of Art, Catherine became a graduate scholar at Trinity College, Oxford. After finishing her D.Phil, she was made a Prize Fellow at Magdalen College, Oxford. Catherine has taught on the MA course at Christie's and lectured at Imperial College, teaching art history to undergraduate scientists. She has also run courses at the Tate Gallery and was a personal assistant at South London Gallery. She lives with her family in London.

Peter Arkle creates illustrations for books, magazines and ads and for a wide range of clients, including Amnesty International, *The New Yorker*, *The New York Times*, anCnoc whiskey, *The Guardian*, *Esquire* and IBM. He has an online gallery at peterarkle.com and occasionally publishes the *Peter Arkle News*, containing stories and drawings about everyday life. Although a native of Scotland, Peter lives and works in New York.